:Illustrated by:

Jeremiah hoppe

:How to contact the artist:

Facebook: https://www.facebook.com/IlluminatedWorldsColoring/

Instagram: @jeremiahhoppe

For single page downloads: https://www.etsy.com/shop/RobotNinjaStudios?ref=hdr_shop_menu

Thank you for your purchase! Don't forget to post your finished pages! share your illuminated worlds!

To my wife, Family, and anyone who supported and believed in me

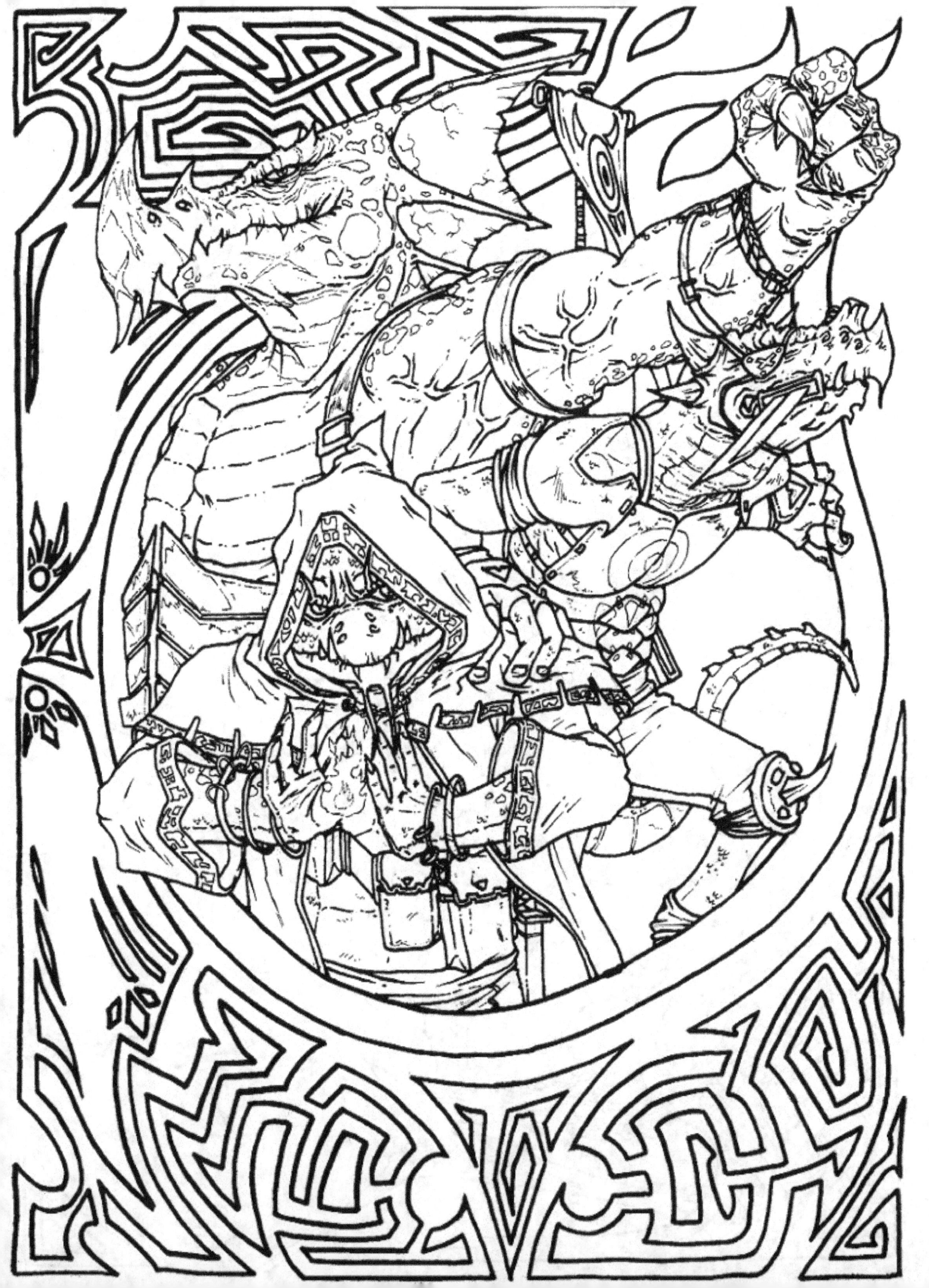

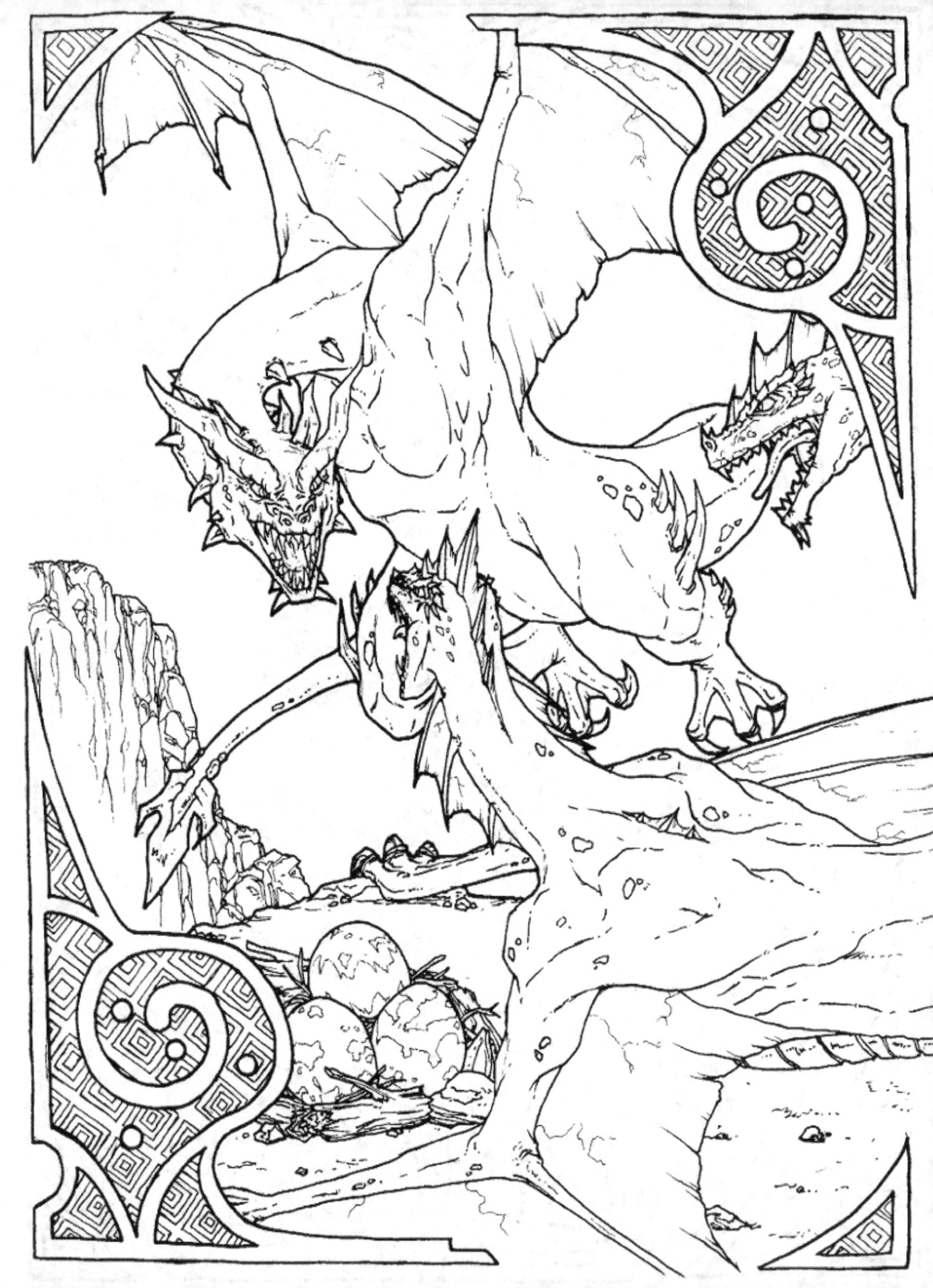

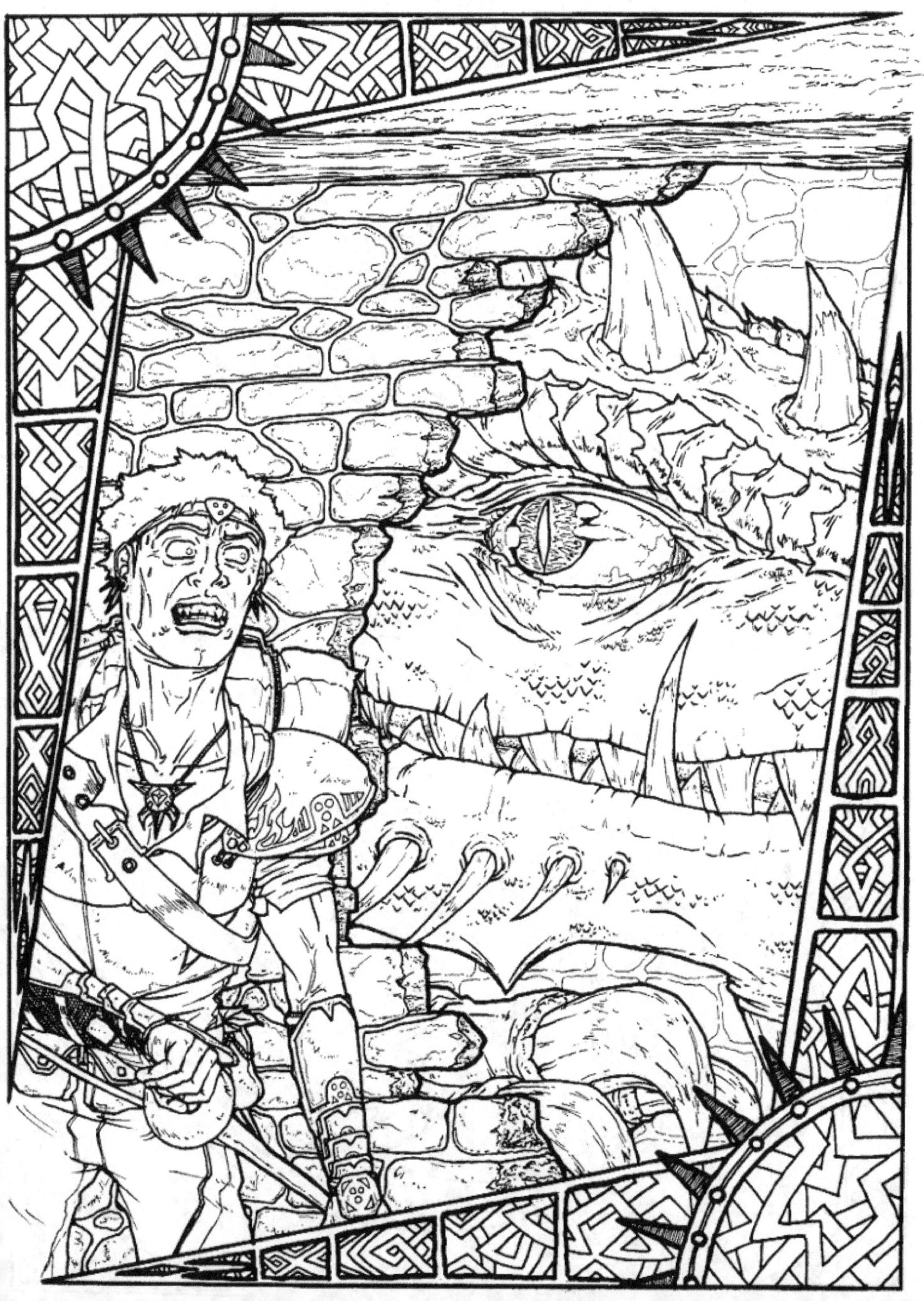

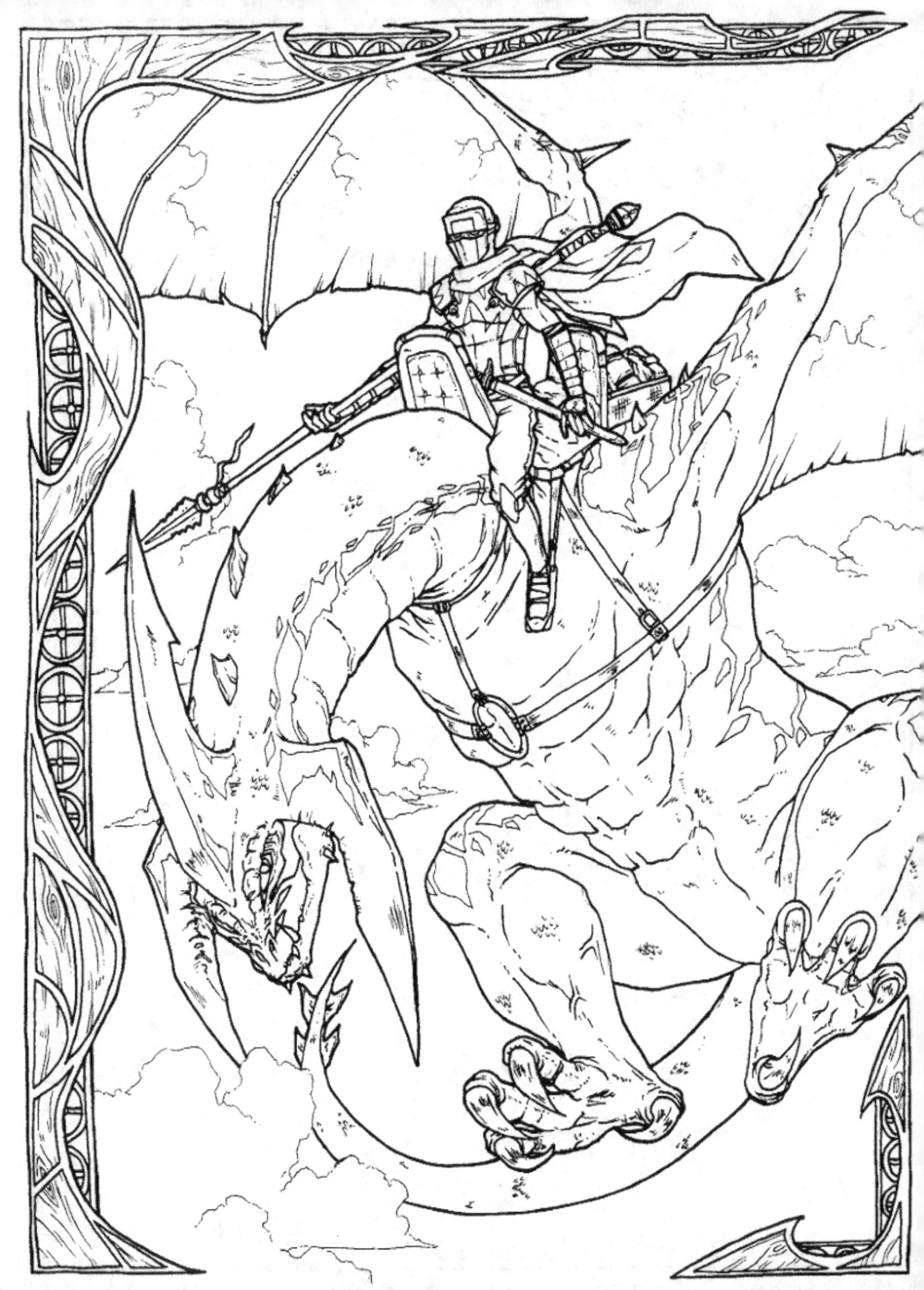

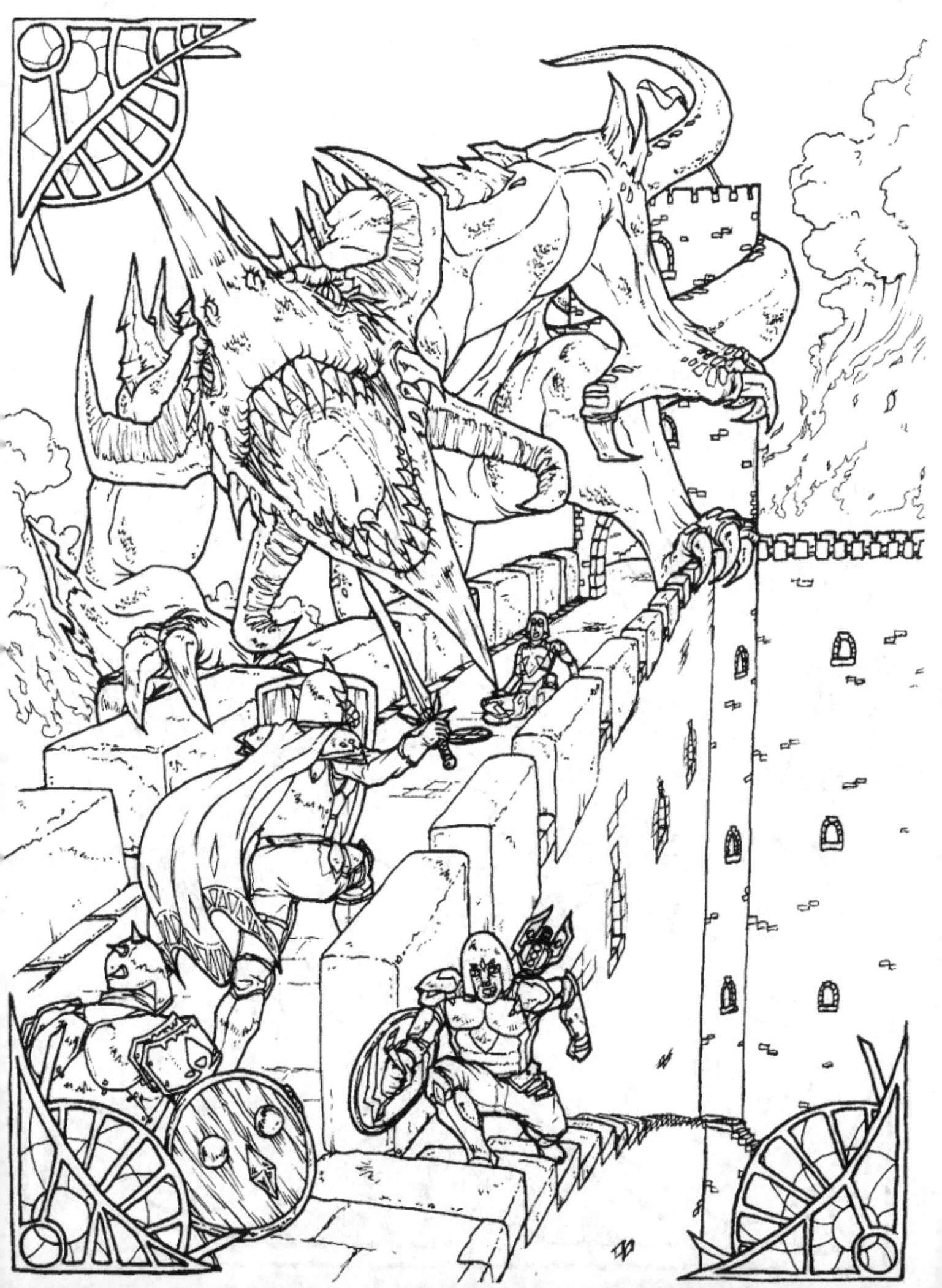

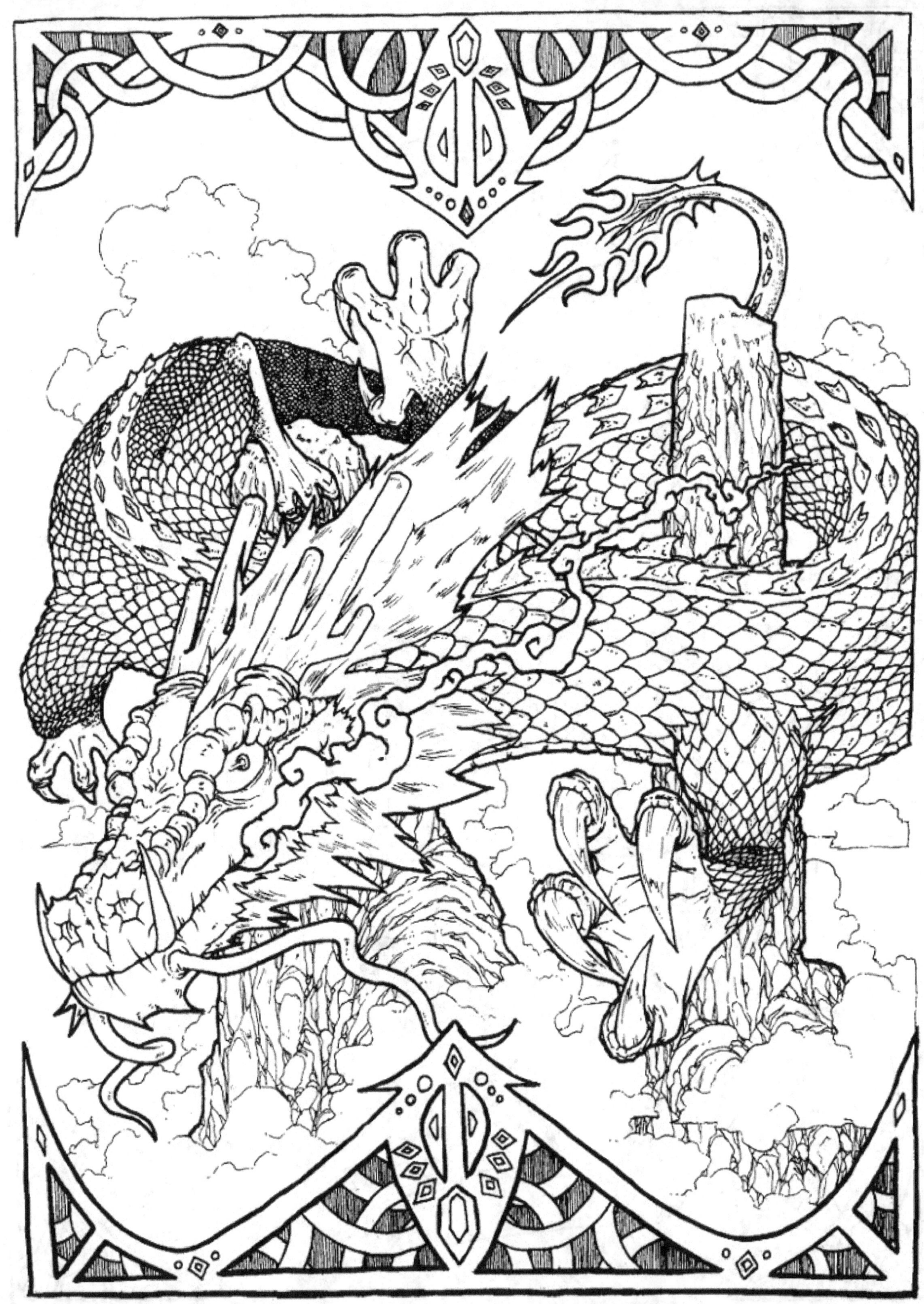

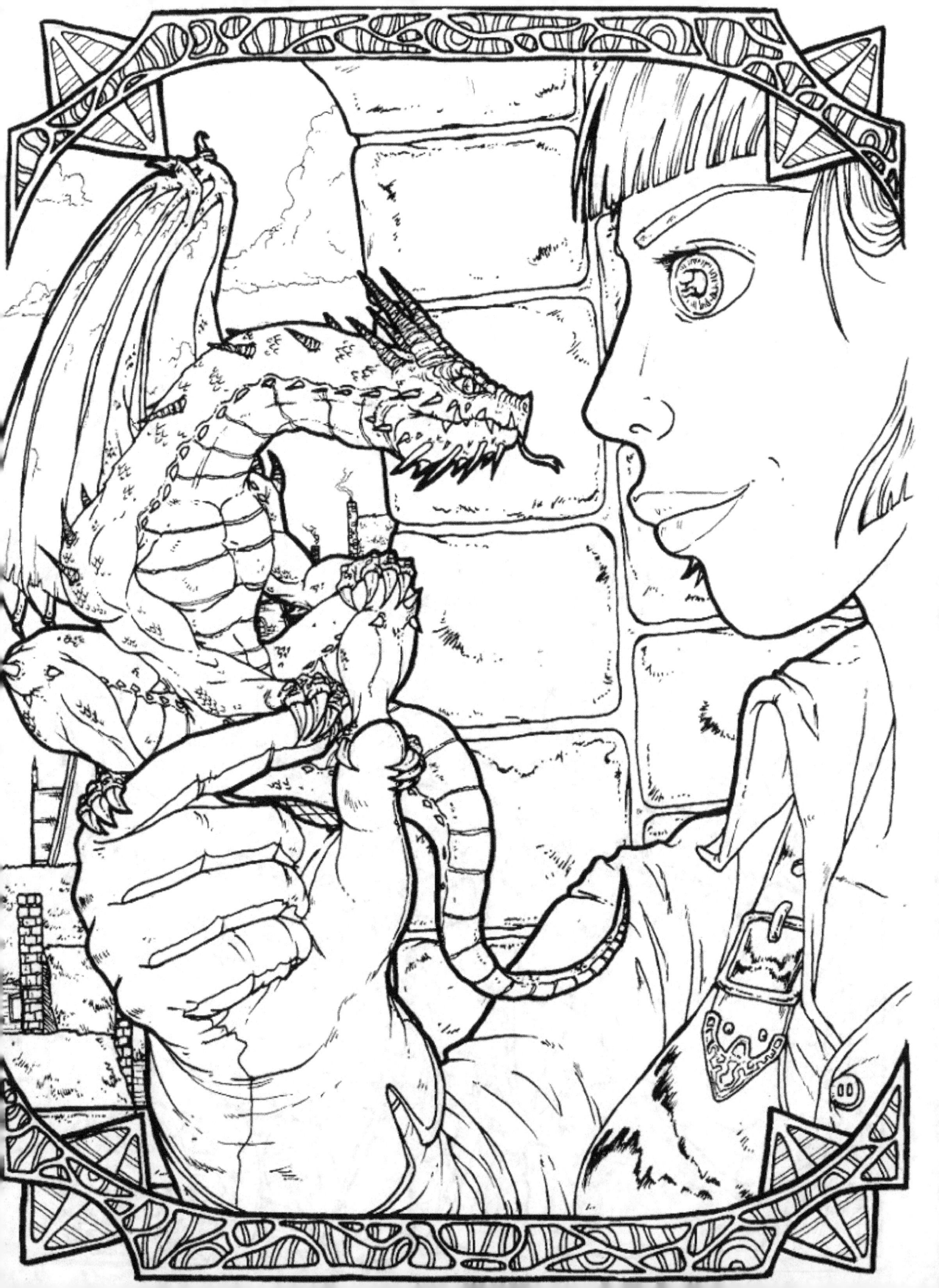

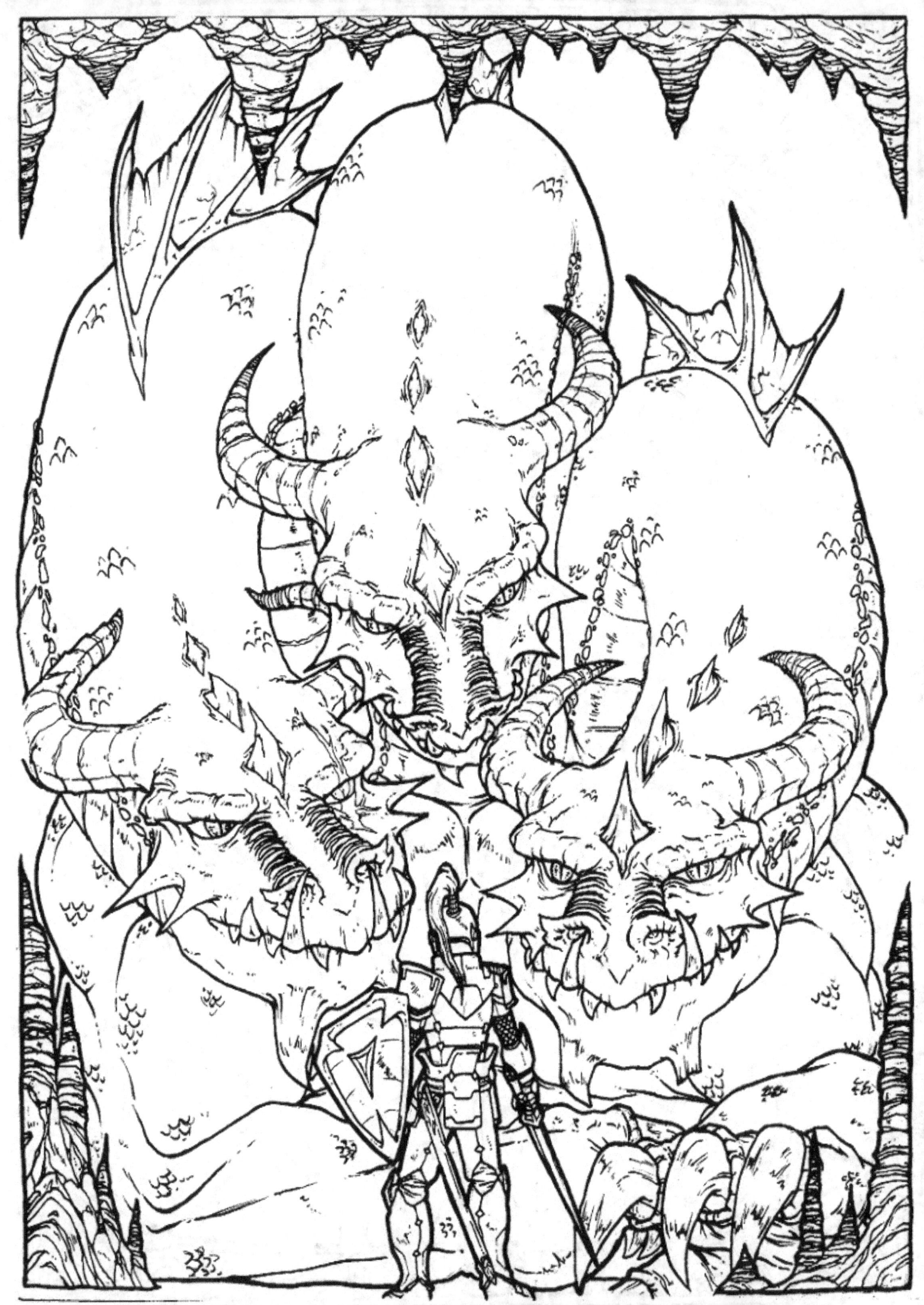

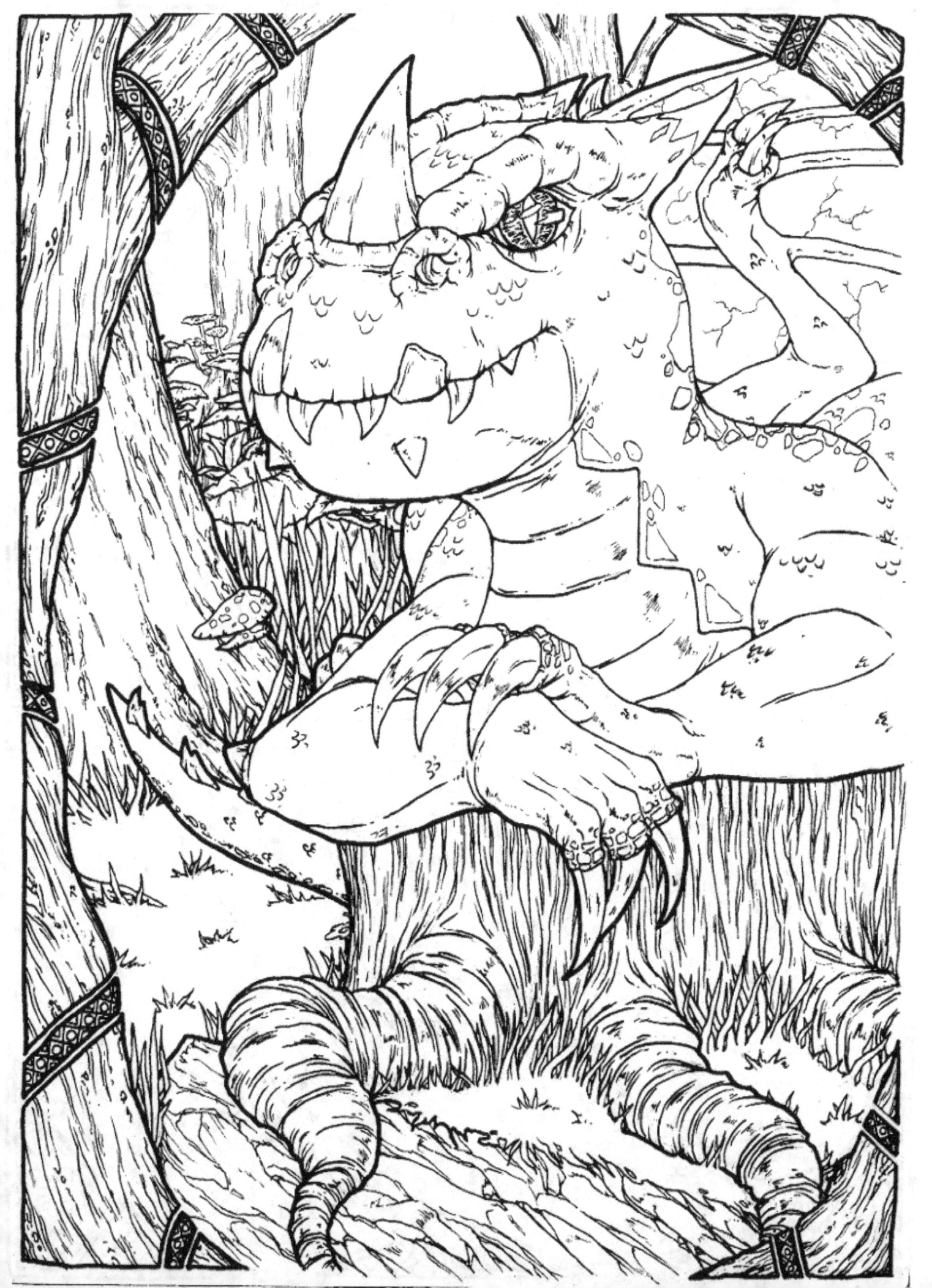

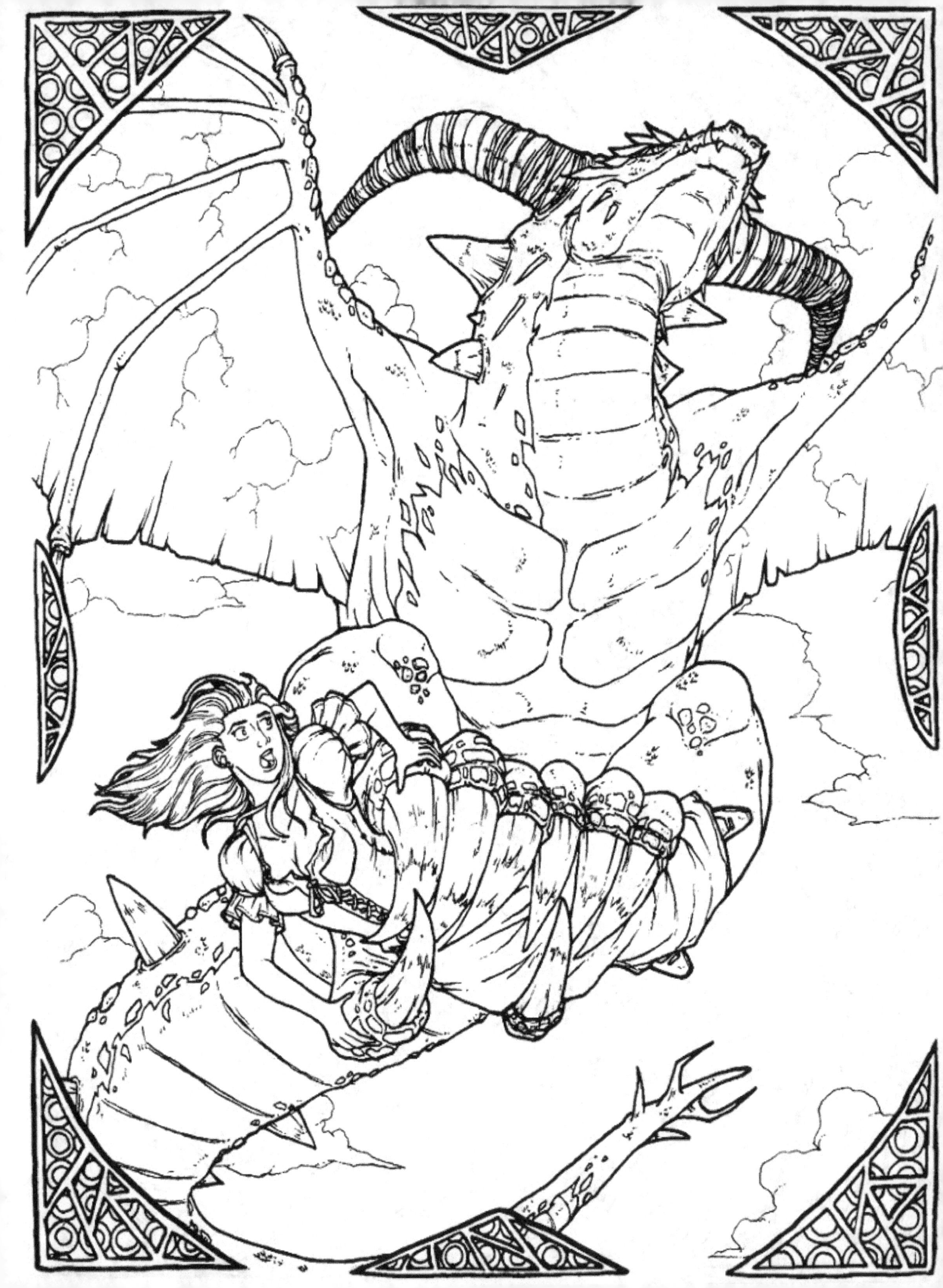

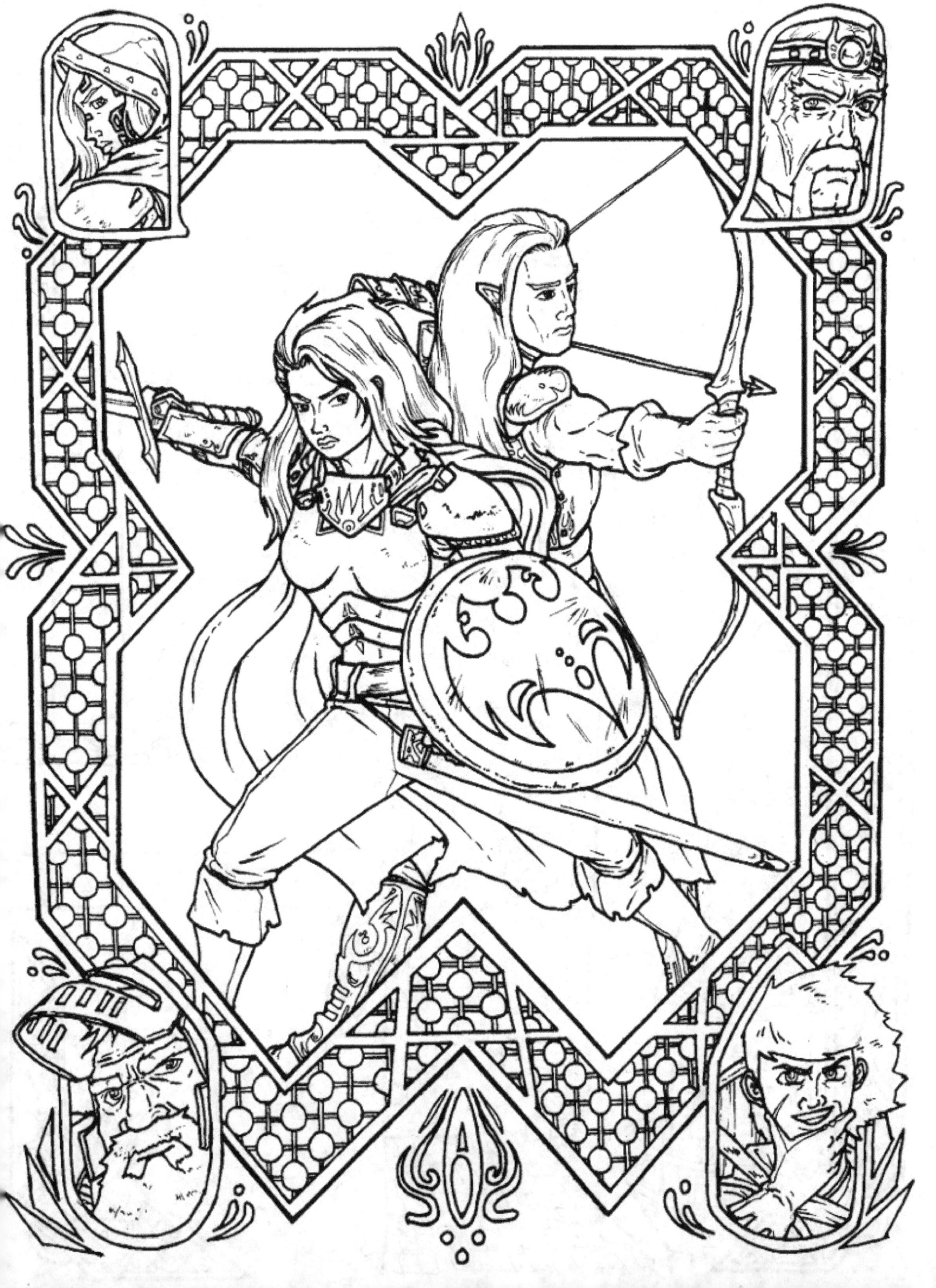

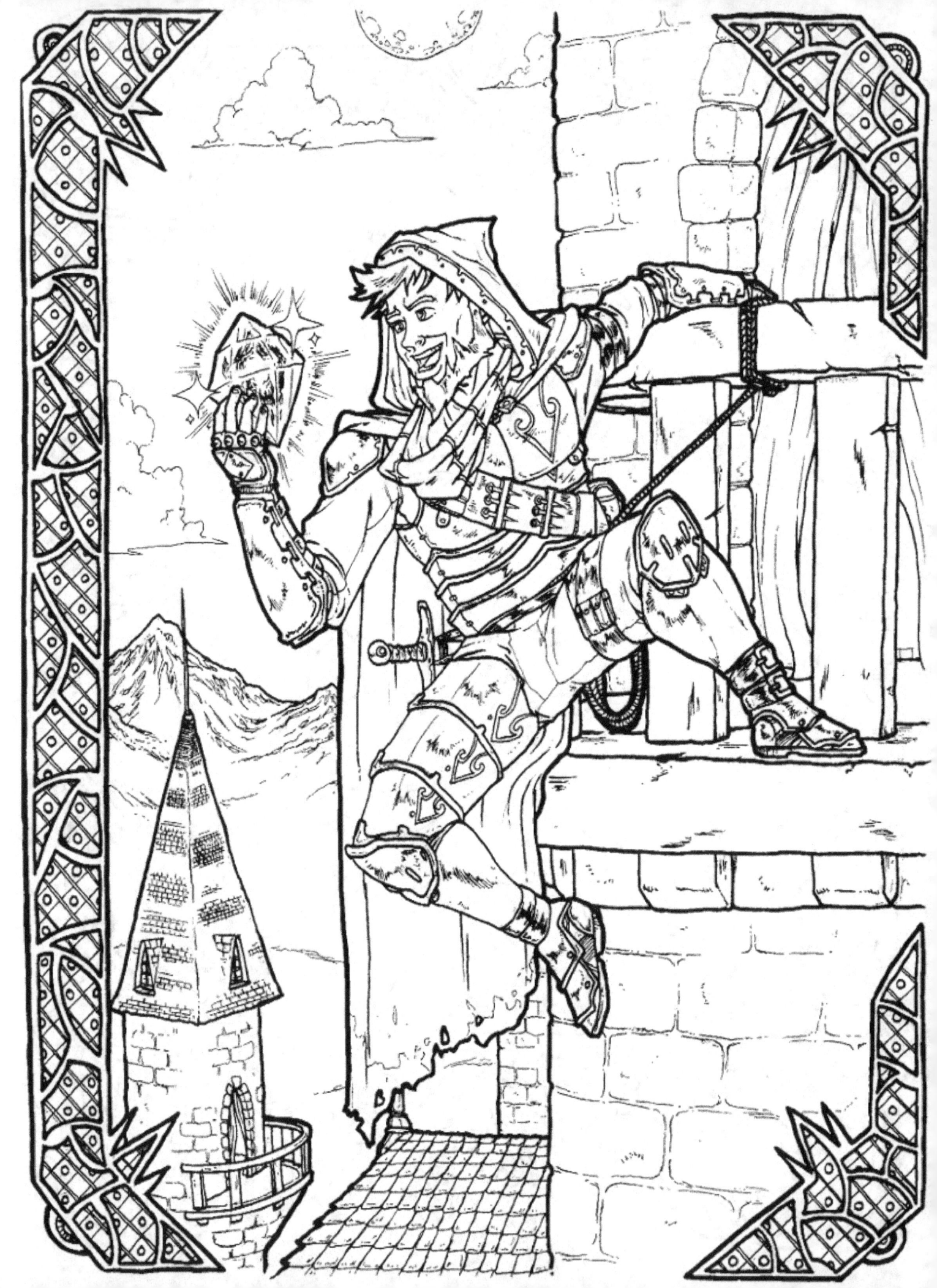

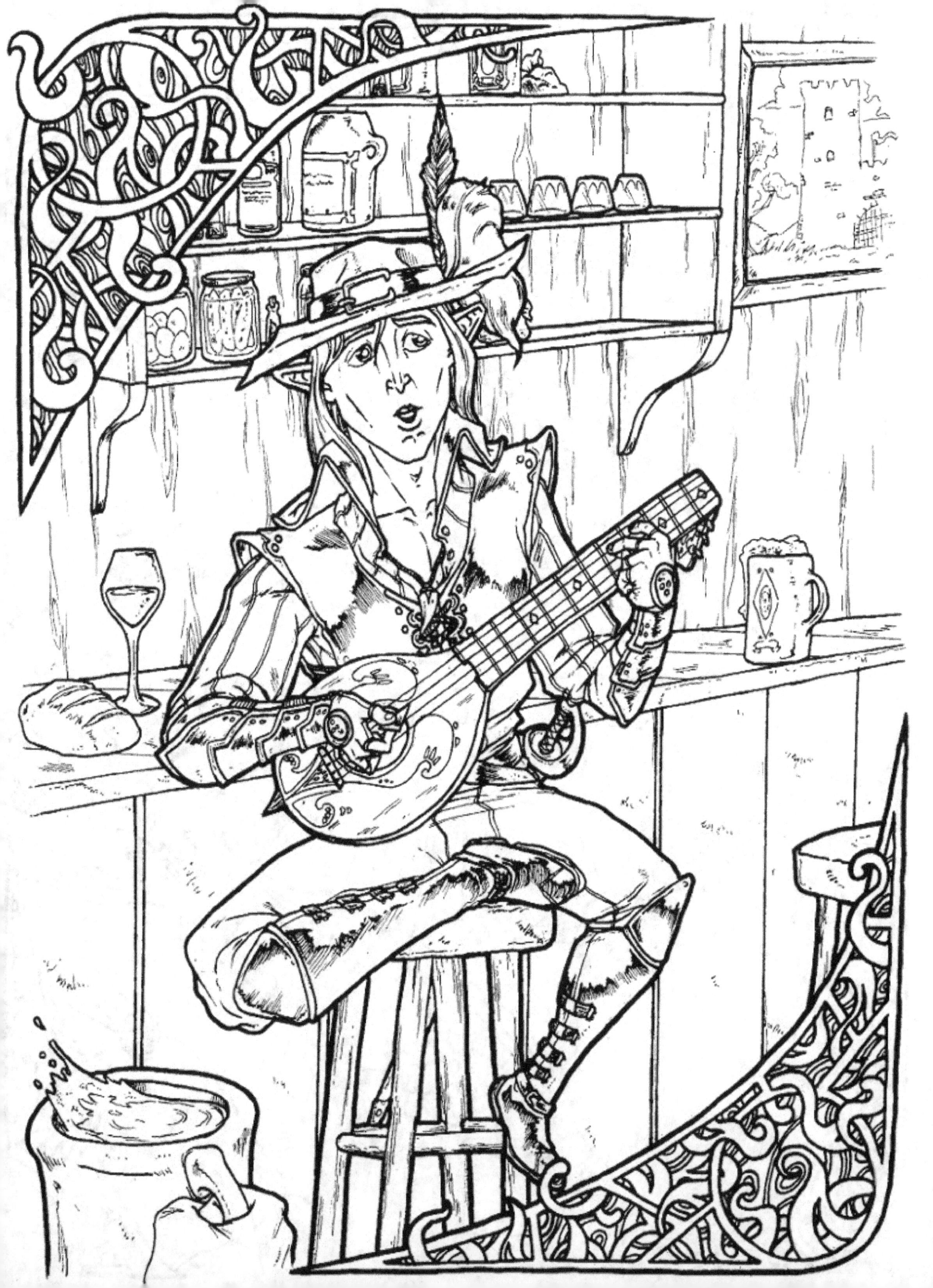

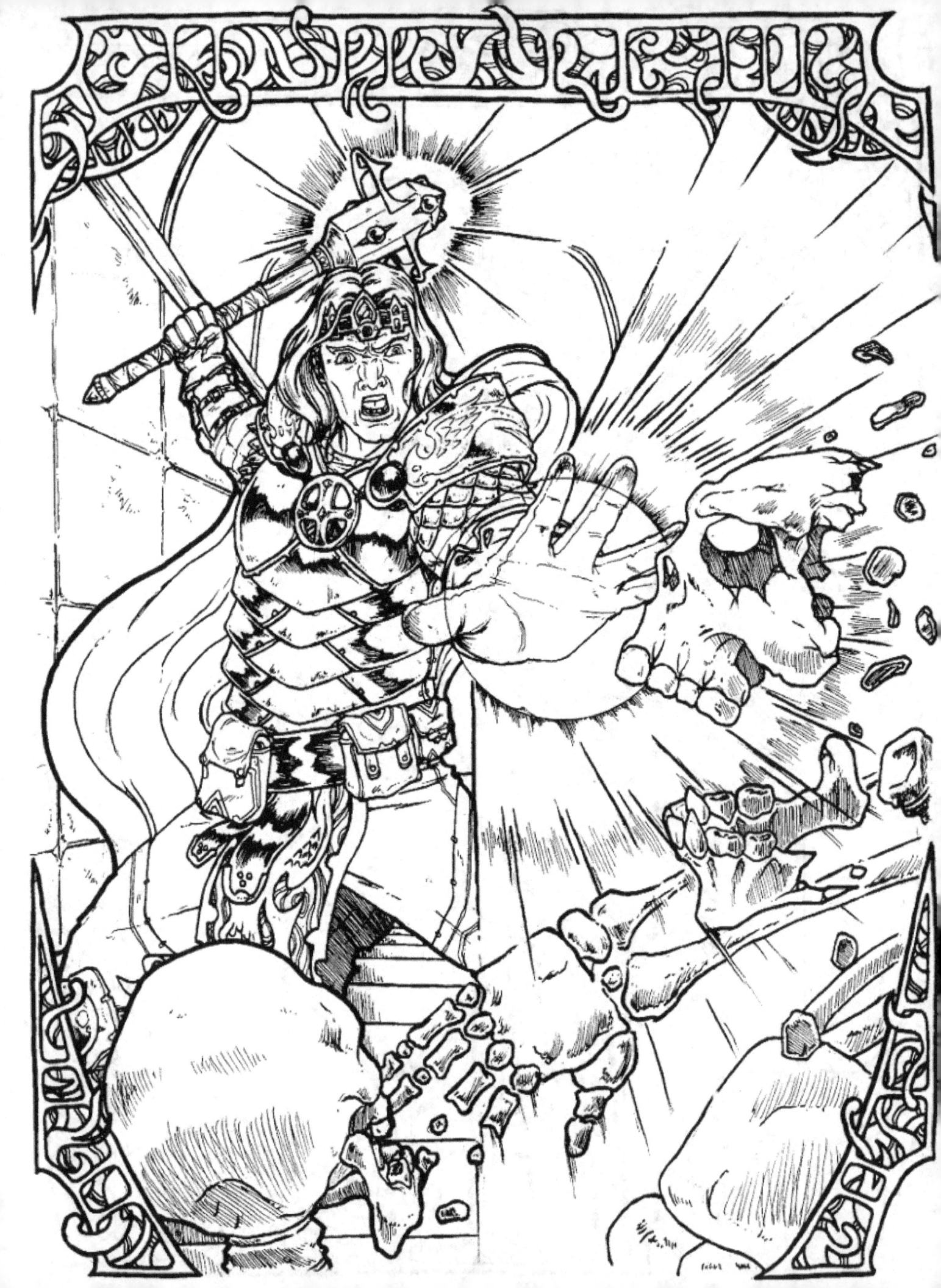

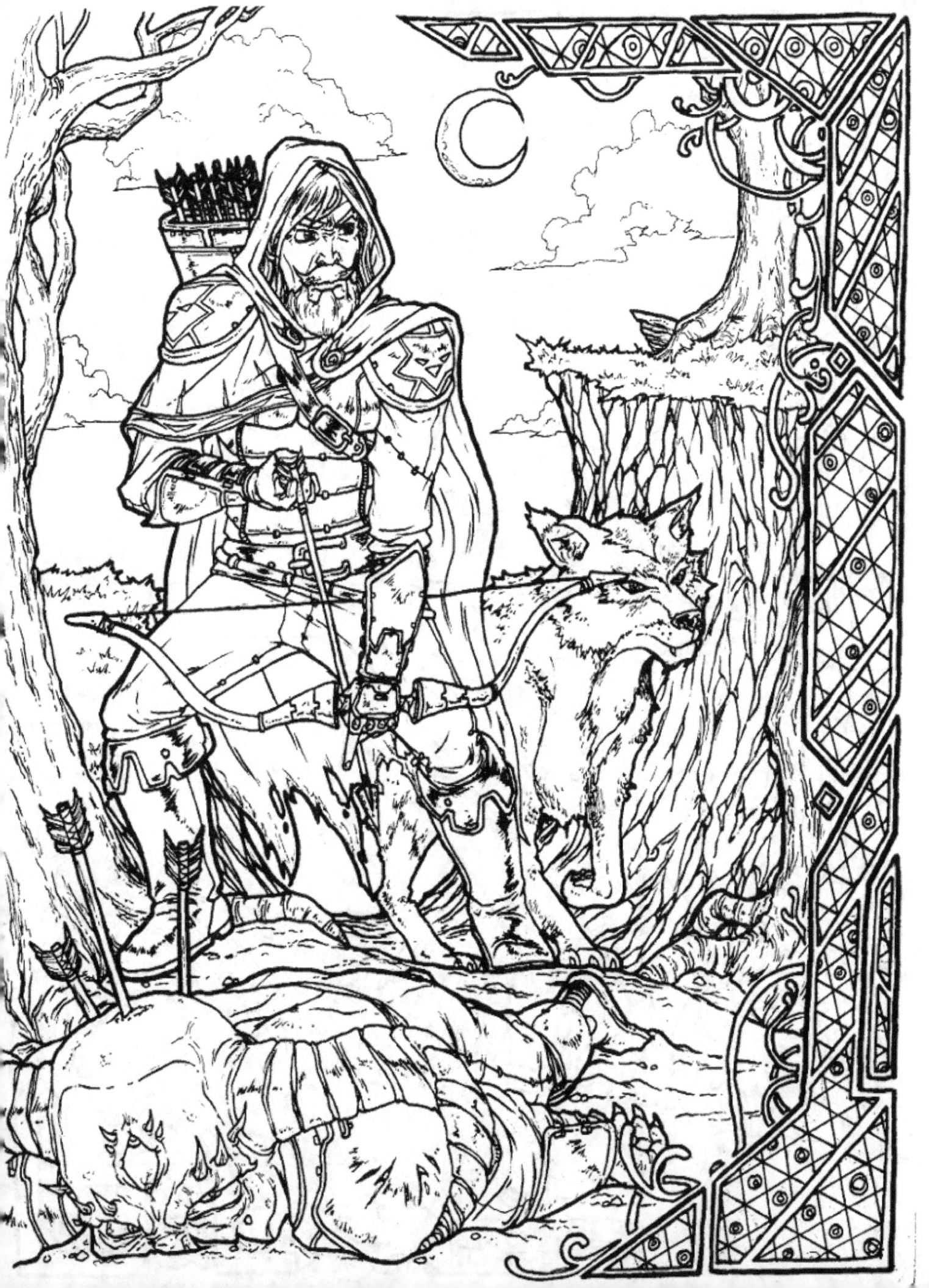

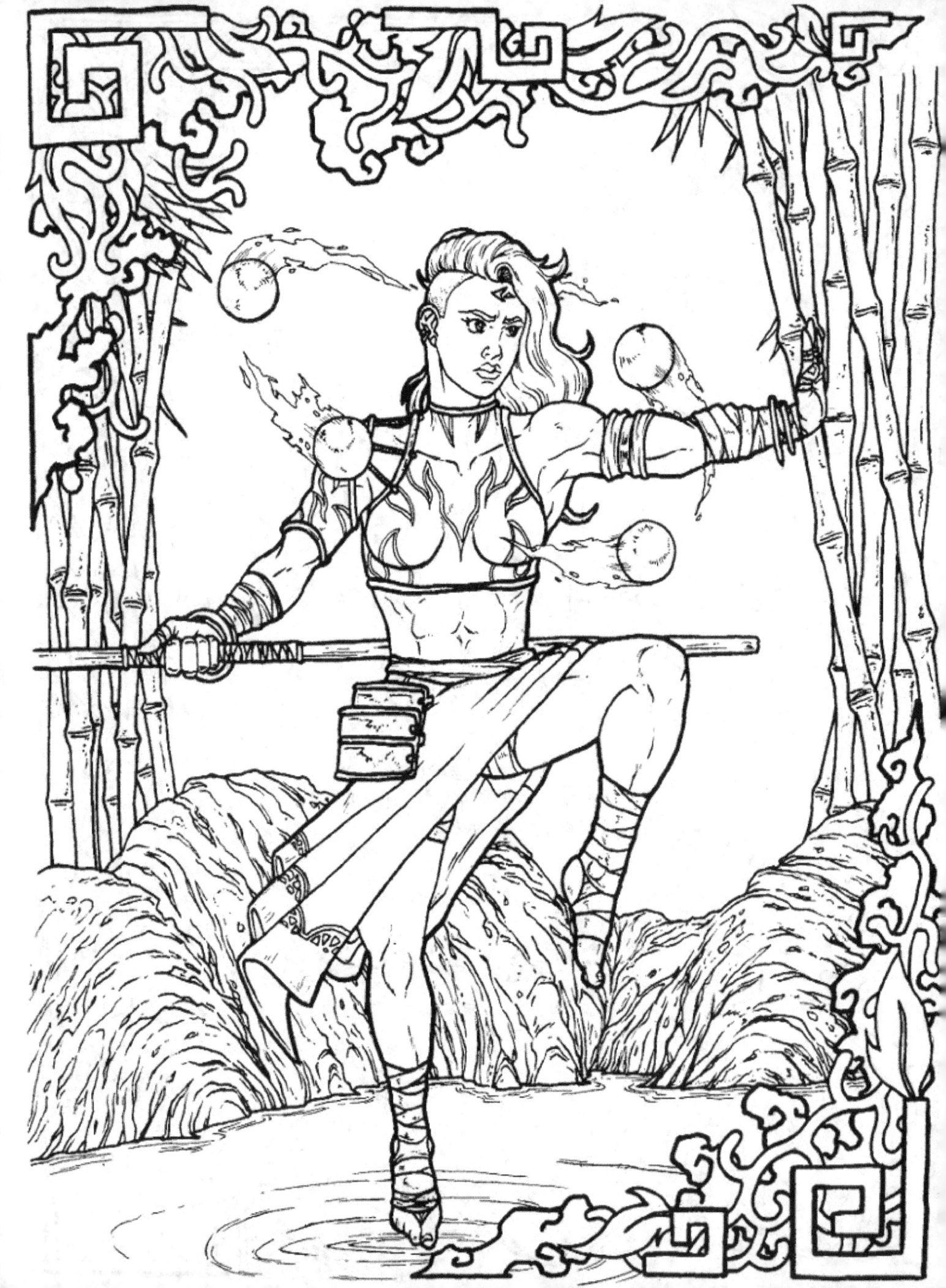

www.ingramcontent.com/pod-product-compliance
Lightning Source LLC
Chambersburg PA
CBHW081135180526
45170CB00008B/3118